The Concept Art Idea Book

J Hunt Graphix
Correspondence: jeffrey@jhuntgraphix.com
Website:http://www.jhuntgraphix.com

The Concept Art Idea Book
© 2017 J Hunt Graphix.
All rights reserved. No part of this book can be reproduced in any form or by any means without prior written consent of the publisher. All artwork unless stated otherwise is
© 2017 J Hunt Graphix

CONTENTS

WIZARD SPIRE	PG 4
1 SPACE STATION	PG 8
2 MAGIC FOREST	PG 13
3 GHOST ORBS	PG 16
4 CITY THAT TIME FORGOT	PG 18
5 SPIRIT FALLS	PG 20
6 ABOUT THE AUTHOR	PG 22

Wizard Spire

Towering over the land is the majestic Wizard Spire. This ancient tower would make a fine home and apothocary for any wizard that walked the realm. Imbued with ancient runes, the tower amplifies the power of the wiz ard making such an owner quite powerful indeed.

This piece was inspired while I was riding my bike during the midafternoon. The cloud formations overhead made a very interesting "C" in the sky and my imagination took off immediately. I saw a huge purple spire rising from the ground up to the clouds in my mind and thought of the digital possibilities. I raced home and I quickly started sketching what I saw on my computer and filled in the mental gaps as I went.

I started the design with a rough pencil sketch. I used the pencil tool in Clip Studio Paint to draw my basic shapes and get the composition the way that I wanted it. Some folks prefer to draw in their sketchbook first and then scan directly in the program.

I then created an inking layer and drew over my pencils so that I could get a good look at the design prior to blocking in the colors. When I do this, I reduce the opacity of the layer so that the pencils fade out a bit.

The tower was created using four layers. One base color layer, one shadow layer, one detail layer, and then one layer for blending. The background and foreground were intentionally designed to wrap around the tower and provide a feeling that the background was swallowing the tower up.

I used darker trees in the front and lighter ones in the back. This provided more of a sense of depth. Highlights were placed throughout the design on the bushes and on the tower where I thought more empahsis was needed.

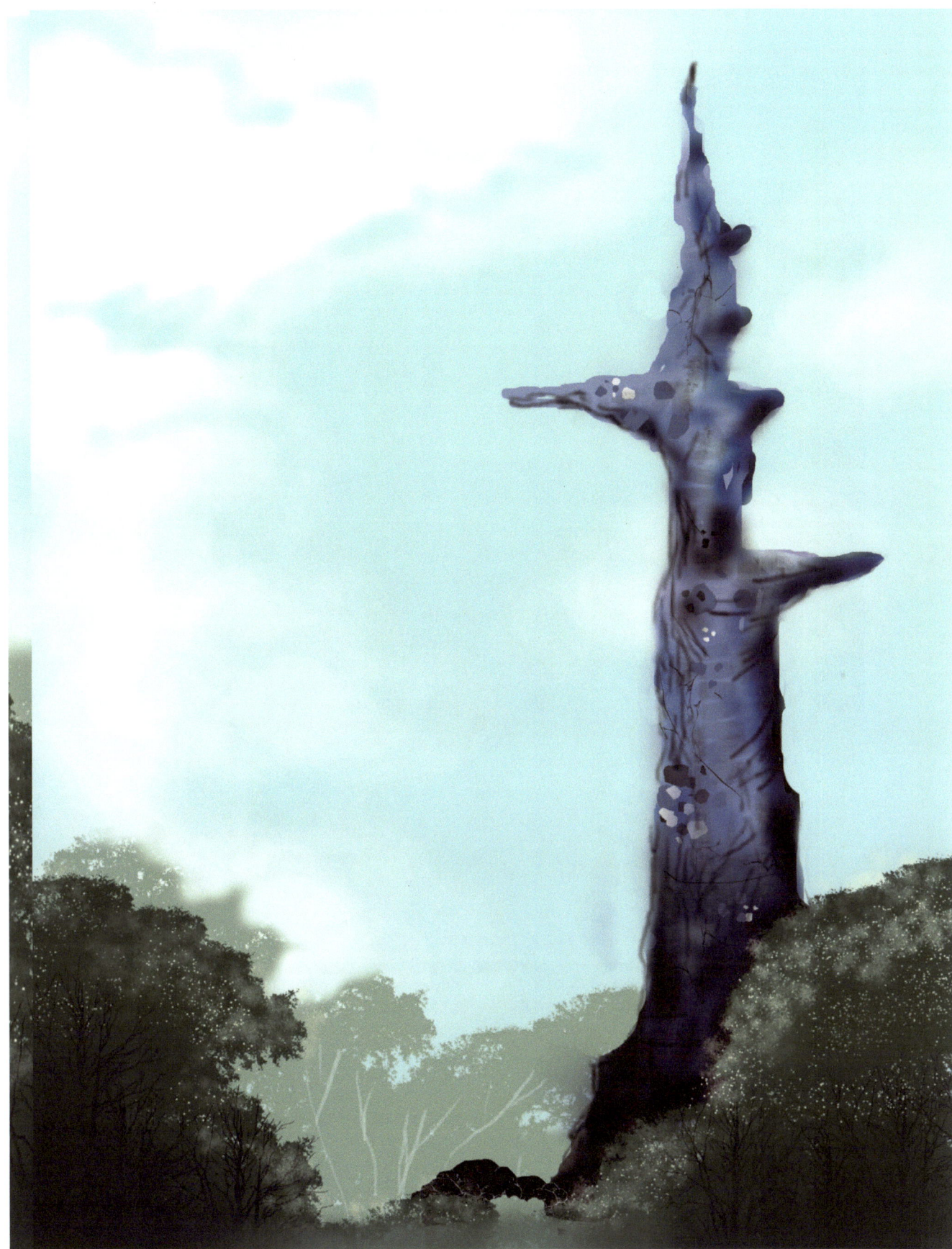

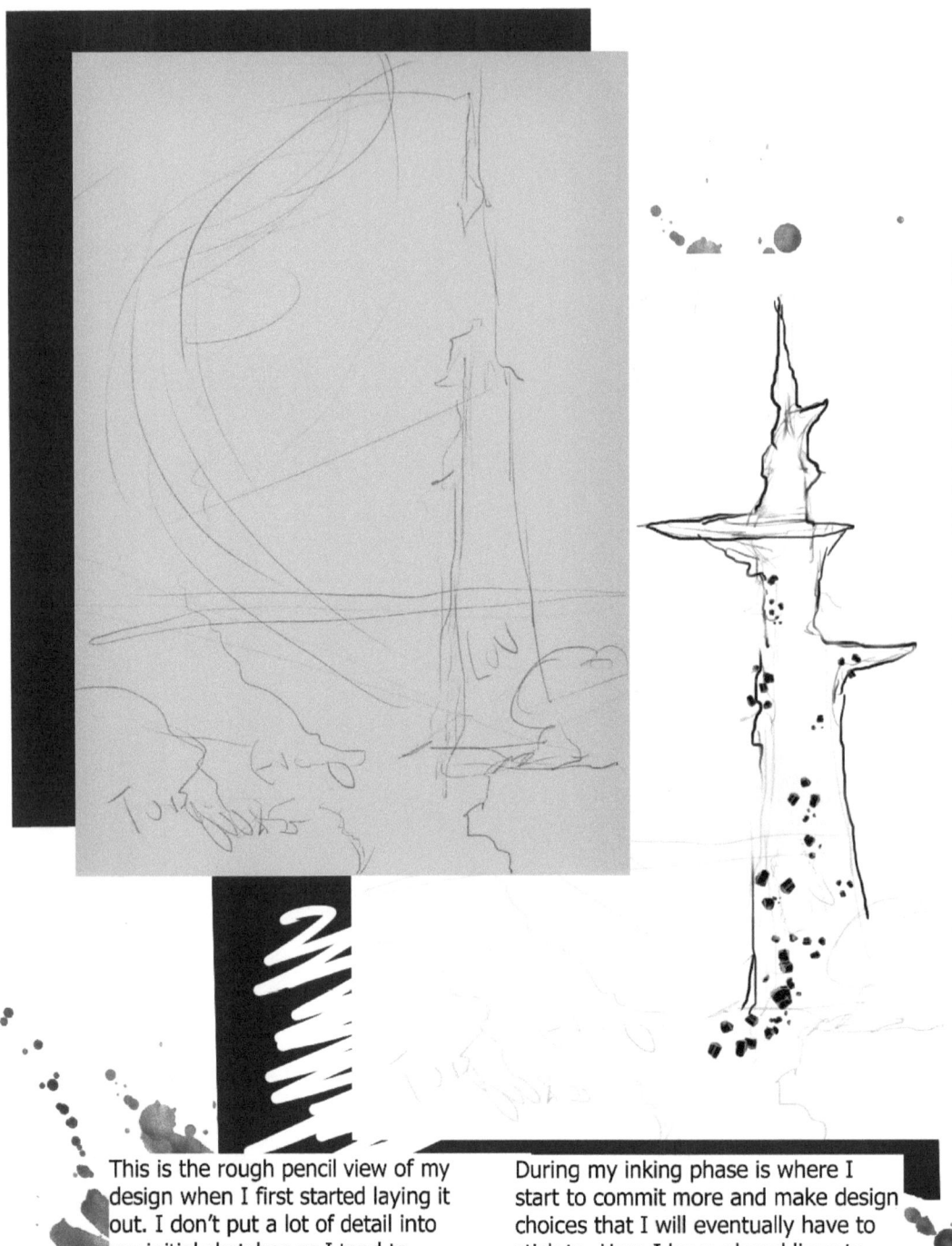

This is the rough pencil view of my design when I first started laying it out. I don't put a lot of detail into my initial sketches as I tend to change my mind as I work.

This non-committal drawing lets me make changes on the fly without feeling like I am stuck to any one course of action.

During my inking phase is where I start to commit more and make design choices that I will eventually have to stick to. Here I have placed lines to better identify the major shapes and assist in the object selection process when I place the color flats in.

"When I add color, I like to think of it as building a model out of clay. You have to build on it until you get it to look the way you want."

Color flatting is easy when you select the area you want to fill with color first. I use a pen selection tool and draw around the area completely and then, while still selected, I use my paint bucket tool to fill the area in. I find that by doing it this way the porcess is faster and sometimes more accurate than just going right in with a pai nt brush.

When I add color, I like to think of it as building a model out of clay. You have to build on it until you get it to look the way you want. Pay attention to value and how it affects composition. Where do you want the reader or the viewer of your artwork to look first?

I made the base of the tower along with some of the rocks darker to start the view er's eyes there and then slowly move up the tower. You start to feel the size and mass as compared to other elements.

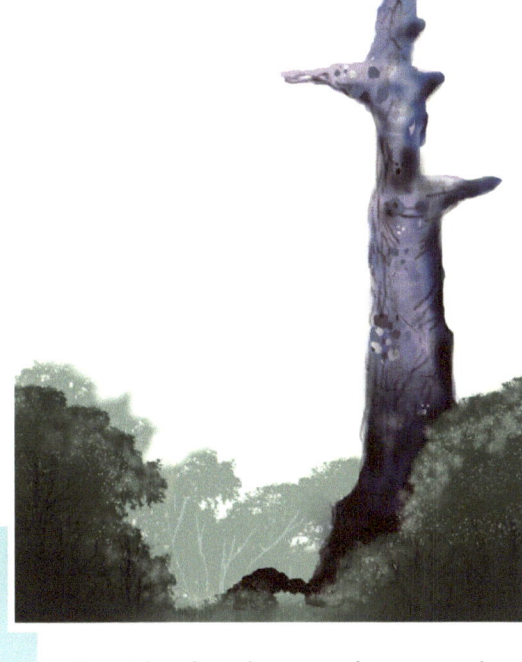

The airbrush tool was used to create the shadows around the entire tower and to put in the runic effects around the tower. Using different tip sizes helped build the texture of the tower by implying shadows where stone may have been placed differently than others.

I made the base of the tower along with some of the rocks darker to start the viewers eyes there and then slowly work up the tower. You start to feel the size and mass as compared to other elements.

The airbrush tool was used to create the shadows around the entire tower and to put in the runic effects around the tower. Using different tip sizes helped build the texture of the tower by implying shadows where stone may have been placed differently than others.

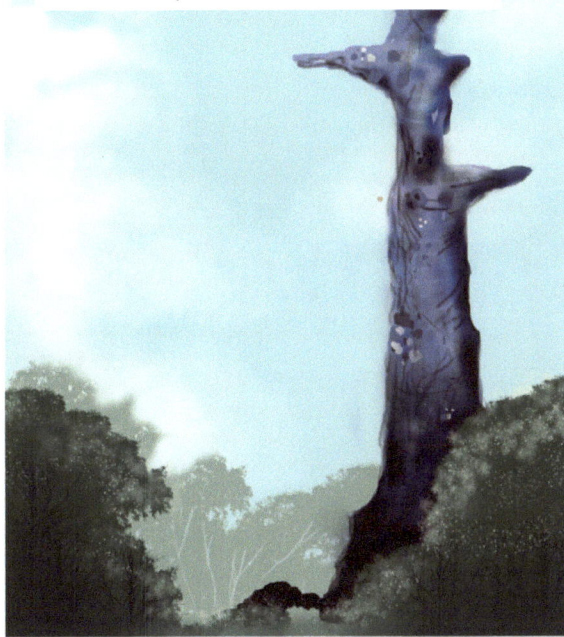

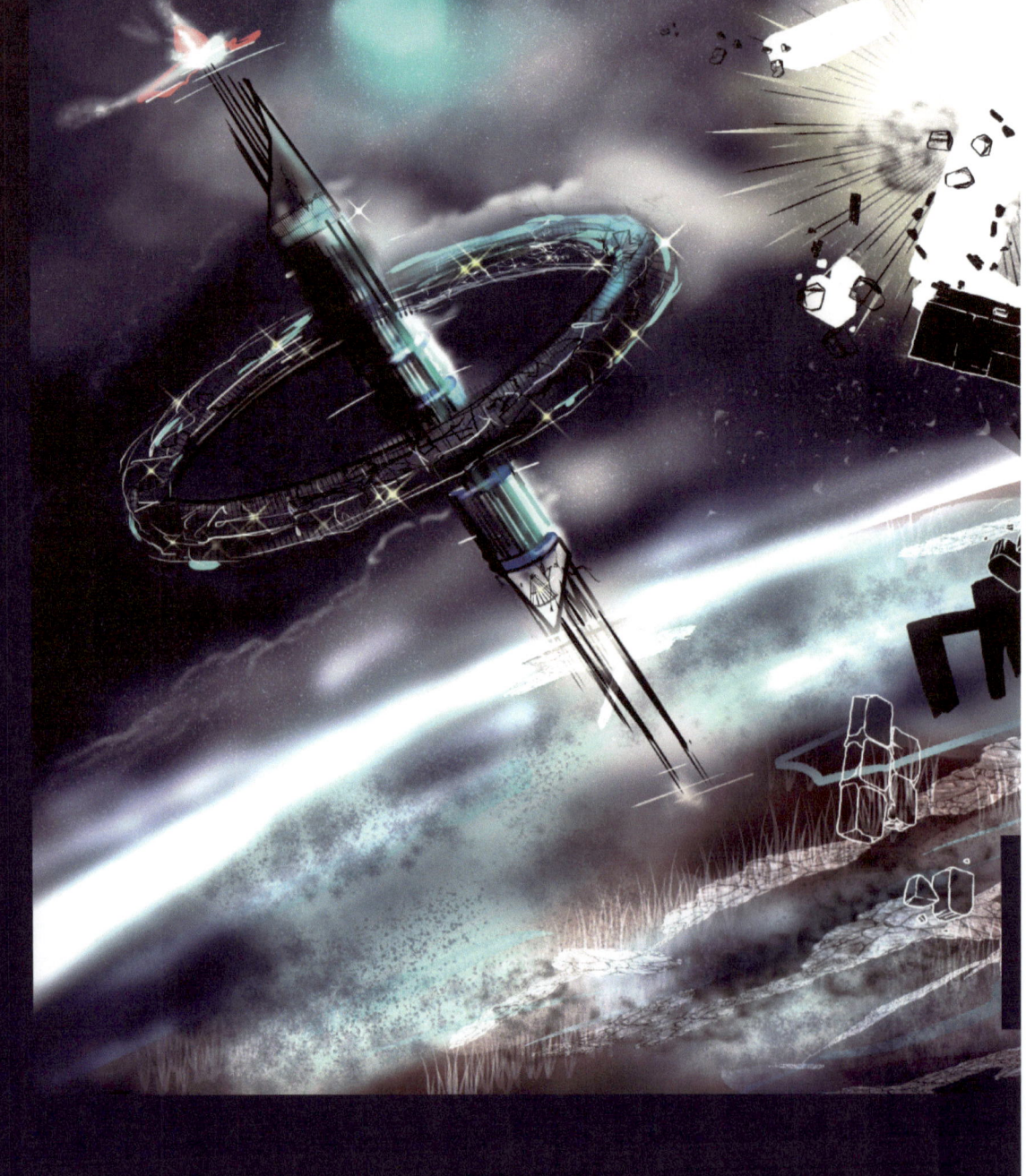

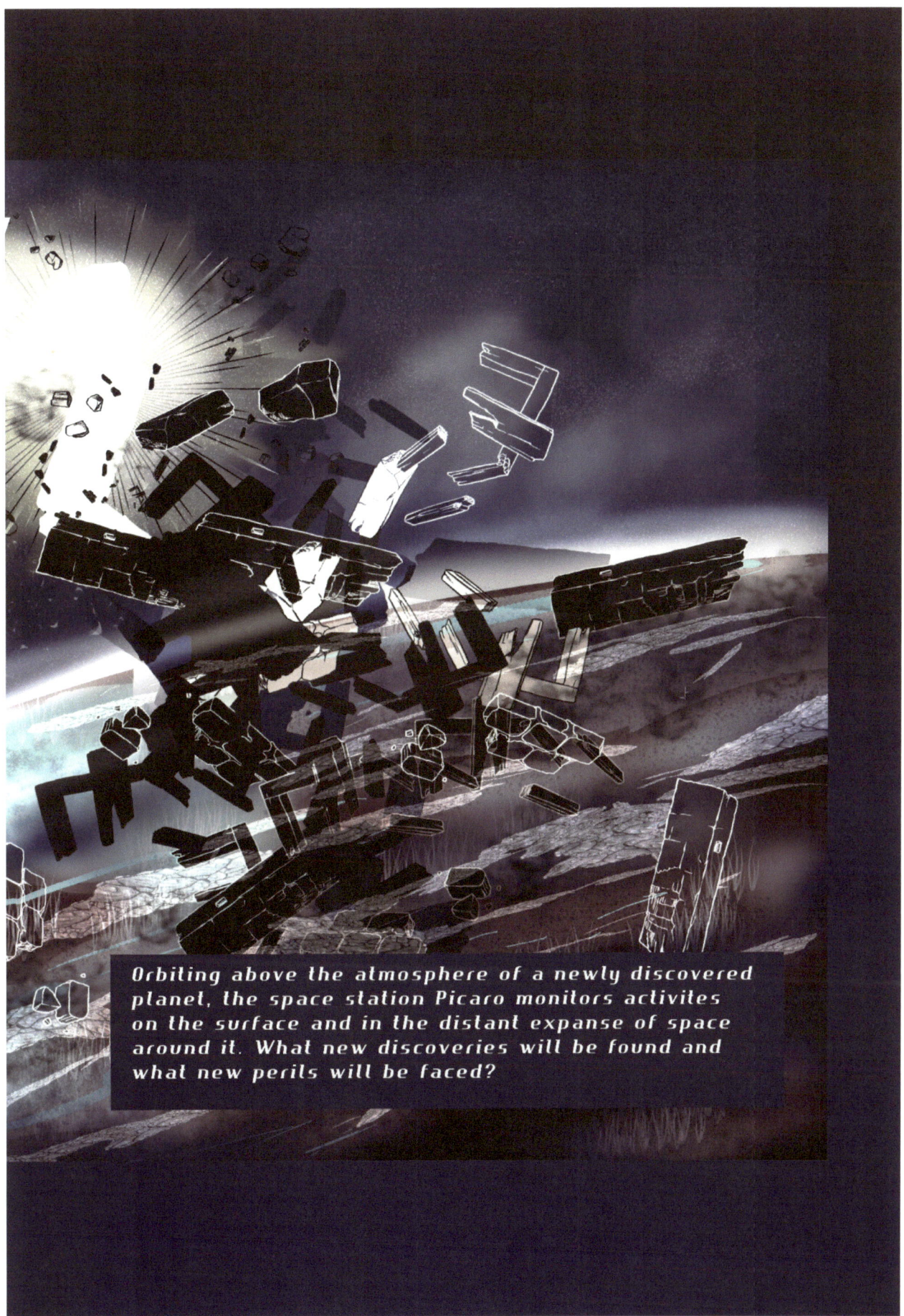

Orbiting above the atmosphere of a newly discovered planet, the space station Picaro monitors activites on the surface and in the distant expanse of space around it. What new discoveries will be found and what new perils will be faced?

"Removing color is just as fun as placing it"

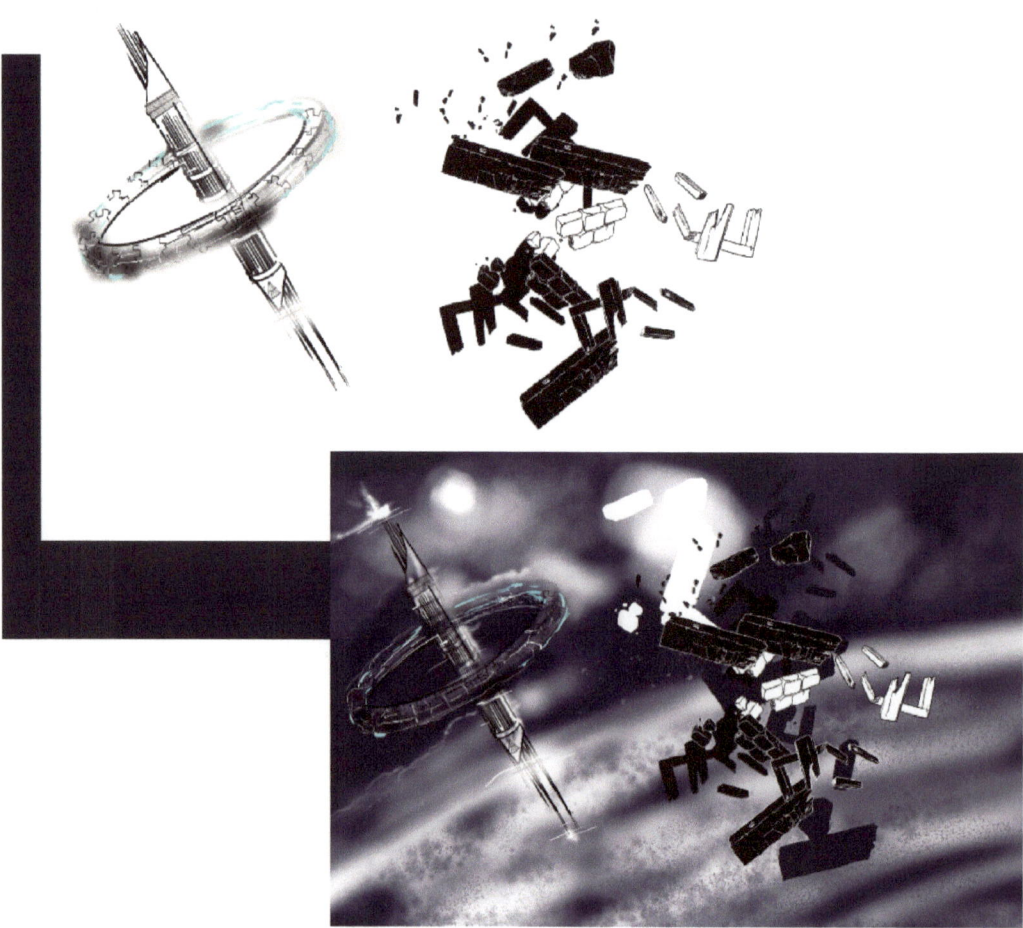

I began this drawing using shape tools. I started with a square and conveted into a long cynlinder to make the long vertical section of the station. I added in some triangles, squares and ovals. A bit of trial and error on my part until I was happy with the design. Air brush tool was used for some shading effects.

Space junk was placed using a special effect tool. I then modified the contrast afterward.

In the next step, I filled the layer with color and then used a cloud tool to remove the color and create the atmospheric effects of the planet and space gases. Removing color is just as fun as placing it. I also put a space storm in the far back.

A small line tool added some lighting to the station and some other details such as antennas, metal plates, and structural designs.

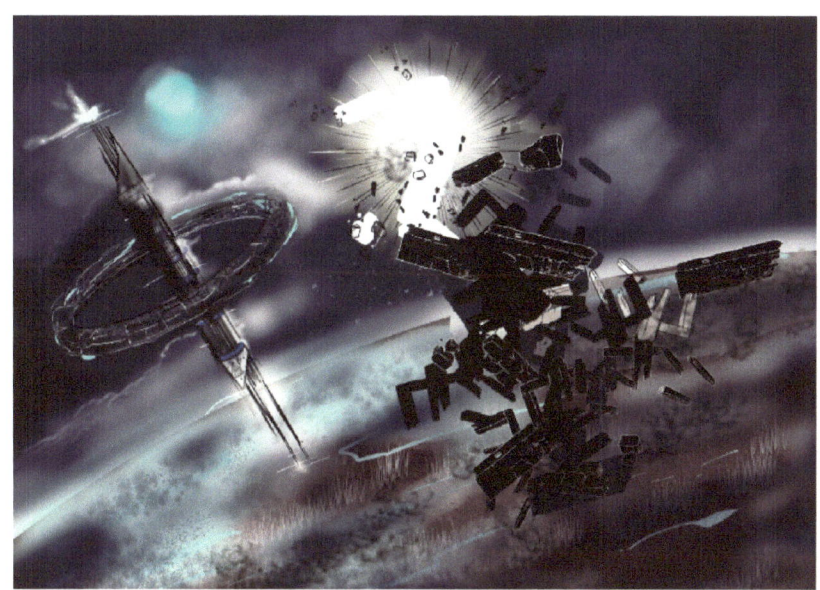

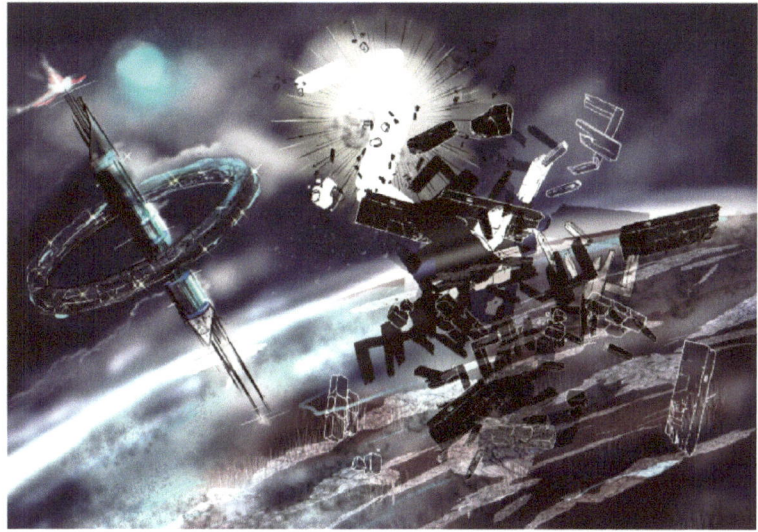

In this last step I added a new layer to make the space effects glow. In fact, the layer type is called a glow layer. This layer has to be top most layer in order to work properly. By taking a brush tool and adding more white where I already had white on other layers below, creates a luminosity that makes the effects pop out.

This should be used with a little discretion as too much will cause the viewer's eys to go all over the place. You want any effects you add to compliment the goal of your composition. It takes some experimentation, but more times than not, less really is more.

Where do I get my ideas?

I watch a lot of television and movies. Specifically, I watch horror movies, shows about spiritual encounters, and other science fiction shows that come on. It is when I am not intentionally thinking of art that I tend to spark thoughts of interesting locations, characters, or stories.

In fact, inspiration usually comes when I least expect it. I have been known to leave whatever I am watching and go right to my art desk and just start sketching away because of a sudden thought that appeared in my head that I just had to put on a digital canvas.

When I go anywhere for a few days, I bring my sketchbook and draw whatever comes to mind. I tend to just scratch incomplete drawings...just enough to serve as a reference for when I come back to my computer. I have to remember to put enough information in my sketchbook so I can pick up where I left off.

I do tend to forget every once in a while just what it was that I was trying to capture.

Never to fear!

This is can be a great opportunity to flesh out a completely new ideas as well. The picture below was drawn from some trees I saw local where I live in Virginia. The water levels were higher from the rain giving them a swampy, spooky, kind of appearance. I was driving home from town when I crossed over a bridge and there they were off the side of the road. The images I saw stayed in my head until I got home and I drew them on my computer.

So where do I get my ideas? All sorts of places really. You just have to find out what works for you.

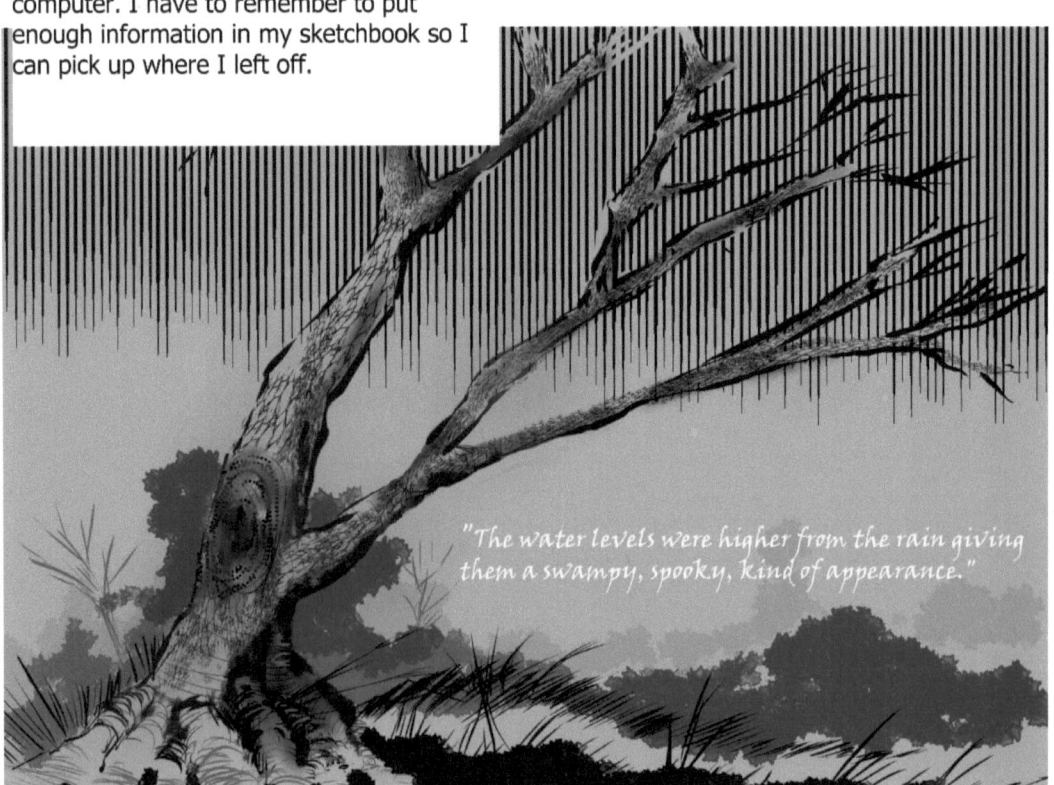

"The water levels were higher from the rain giving them a swampy, spooky, kind of appearance."

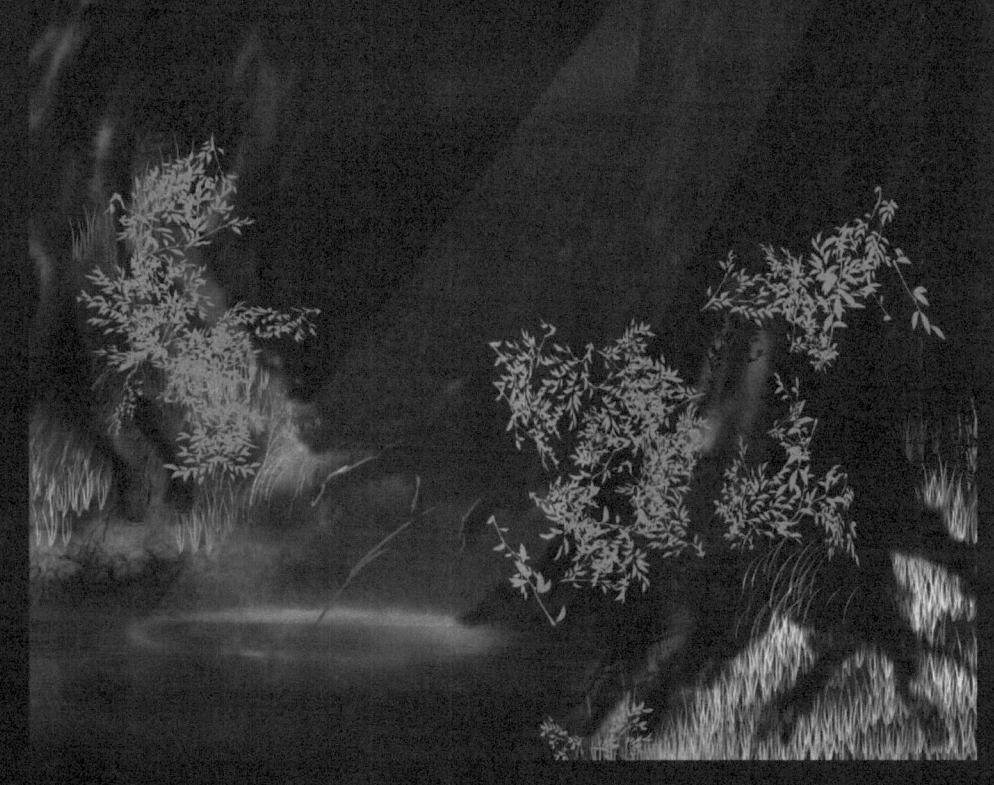

I really wanted to create a dark and lush forest scene. As you can see from my initial sketch, I left a lot of things open for change as I progressed through this design.

Light sketches of where I thought I wanted the trees was really all I needed to get started. Again, this is my process for connecting my ideas to my sketchbook or in this case, my digital platform.

I believed that my focal point would be in the low center of the page. You can see when I placed marks where I wanted emphasis to point the viewer to.

I spent much more time on inking as I wanted to put a lot of detail into the textures of the trees and plants. The trees in the background were mostly drawn freehand.

The foliage was created by using vegetation tools of various plant styles. I find using these tools speeds up the process of depth and completion of the entire piece.

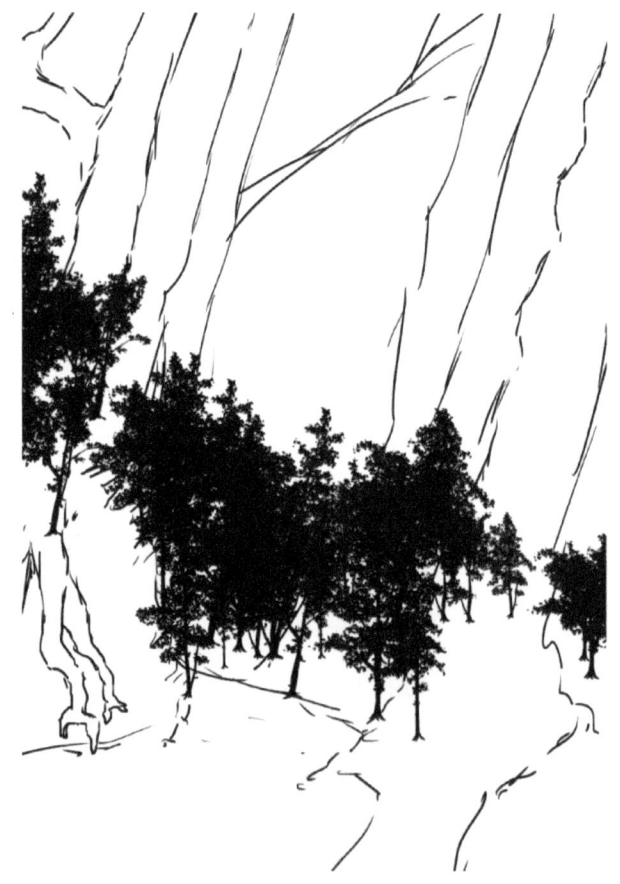

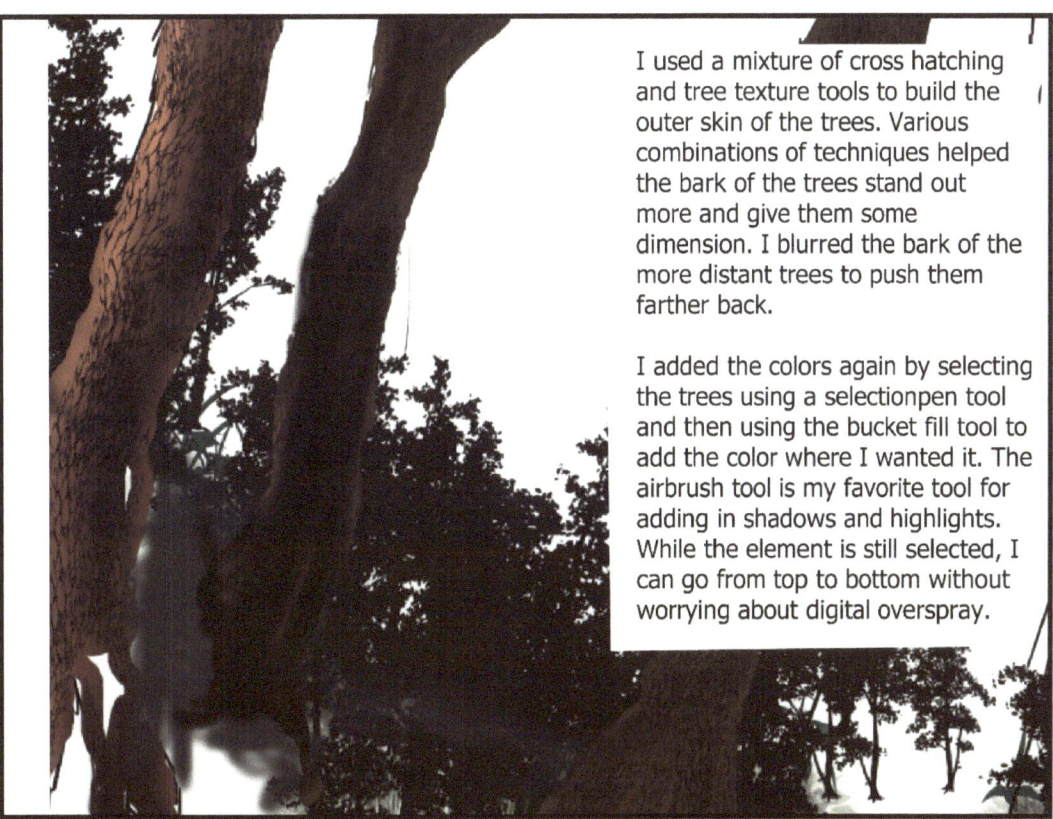

I used a mixture of cross hatching and tree texture tools to build the outer skin of the trees. Various combinations of techniques helped the bark of the trees stand out more and give them some dimension. I blurred the bark of the more distant trees to push them farther back.

I added the colors again by selecting the trees using a selectionpen tool and then using the bucket fill tool to add the color where I wanted it. The airbrush tool is my favorite tool for adding in shadows and highlights. While the element is still selected, I can go from top to bottom without worrying about digital overspray.

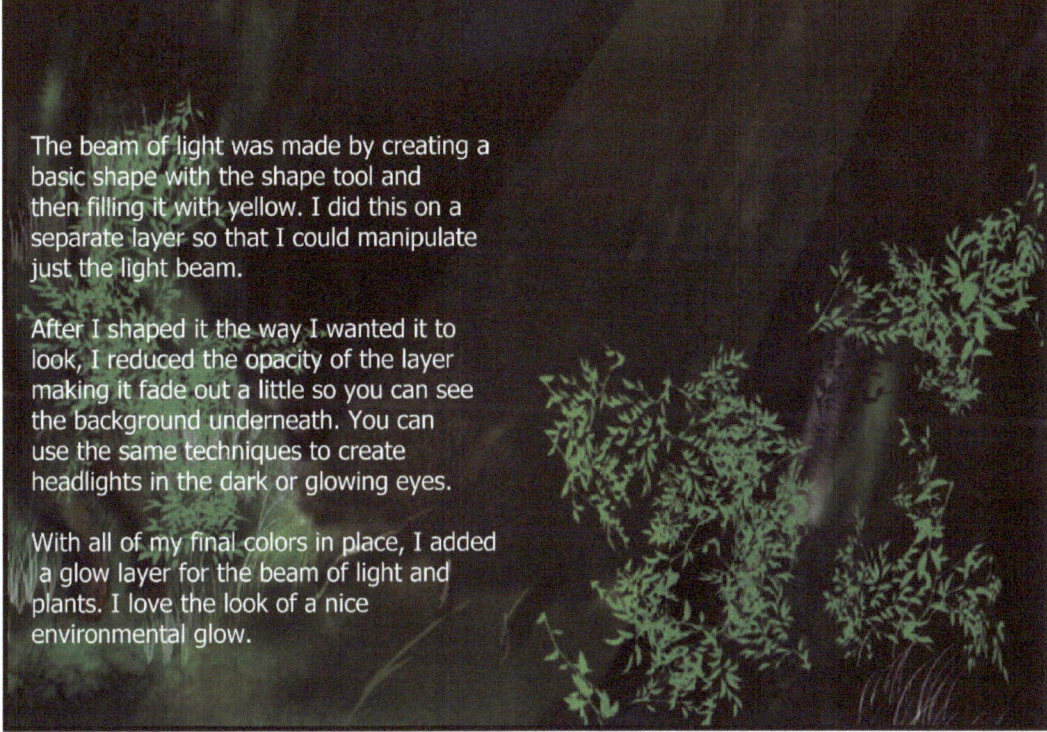

The beam of light was made by creating a basic shape with the shape tool and then filling it with yellow. I did this on a separate layer so that I could manipulate just the light beam.

After I shaped it the way I wanted it to look, I reduced the opacity of the layer making it fade out a little so you can see the background underneath. You can use the same techniques to create headlights in the dark or glowing eyes.

With all of my final colors in place, I added a glow layer for the beam of light and plants. I love the look of a nice environmental glow.

Ghost orbs

Ever walk into a forest and see ghostly orbs fly around you? This is what it might look like if you do. I imagine a lot of activity all at once, as if an energy burst is suddenly being released, until finally pulsating out of existence.

This piece was designed in black and white to create a spooky mood accentuating the darkness and shadow of the night. The orbs are a bright contrasting white so they are able to communicate their presence, movement, and let everyone know they are there.

This piece was designed using four layers. The initial pencil layer was later converted and used as a detaill ayer toward the end of the design. The other layers used were an ink l ayer, background layer, and shadows layer.

To create a more 3 dimensional appearance, elements of shadows a nd highlights were placed throughout all of the layers with a proper amount of blending where needed to fuse the elements

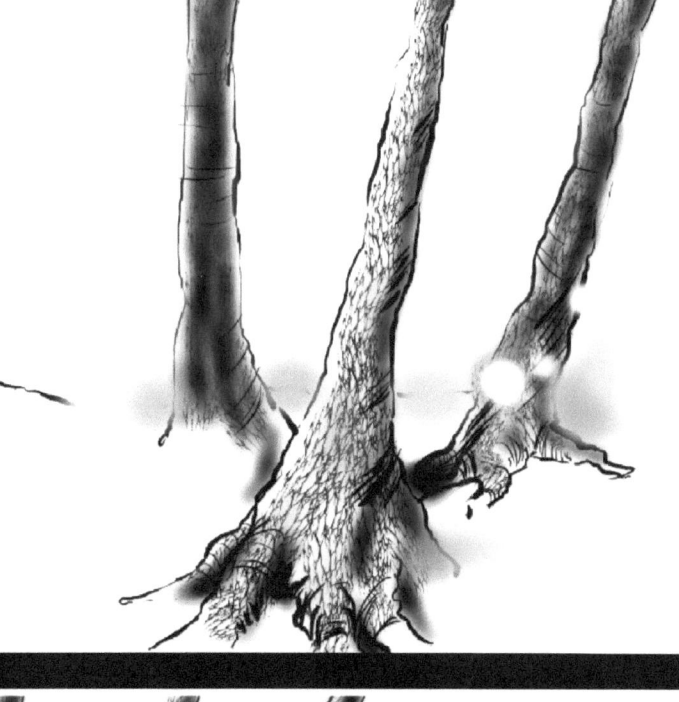

The trees were created with a thick inking brush with fine detailing after ward. A tree texture tool was used to give more of a bark look to the skin of the tree. This also allows for more interesting shadows as they were placed with an air brush tool.

The bushes in the foreground were created with an ink wash set to a grey tone much like taking a sponge to a piece of paper with ink. Just enough texture to provide the look of bushes without much more but it helps to frame the piece together.

In the background I placed a slow moving mist moving throughout the trees again to provide some more depth and make it seem as though the orbs were traveling through the woods. The far background has a number of different tree and grass designs making it seem dark and very difficult to find your way through.onjoy this piece...be sure not to get lost should you enter the woods alone and unafraid.

CASTLE ON THE
EDGE OF TOMORROW

Holding the line between one reality and another stands a magnificent castle. The iron forged battlements stand at the ready as the last line of defense charged with either keep something out or keeping something in. The rest of the story is up to you.

I love castles…everything about them. I have been chomping at the bit to create a castle scape of some sort and this image came to mind while looking at some pictures of castles on the internet.

This one was based on a castle in Ireland that I found. It was a bird's eye view so I change the point of view so that the viewer would look at it from the ground.

It was then I got the idea to put the cave exit in the foreground as if you had to get to the castle from somewhere else.

I have thought castles to be intimidating so I spent some time putting my pencils in the first layer. I placed as much as I wanted show in the composition without making it too complex.

The next layer I went in and inked the major outlines, some details, and shadows with my airbrush tool.

In third image, I am experimenting with color correcting and hue correction. The colors are turned off you can see the area better. By manipulating the color settings, I was able to get more of dusk look to the background. This really set the castle off.

The last step of this process I added the glow layer for the sky and some reflection off of the castle itself.

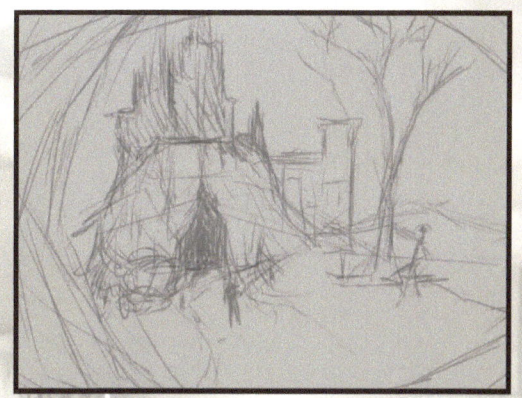

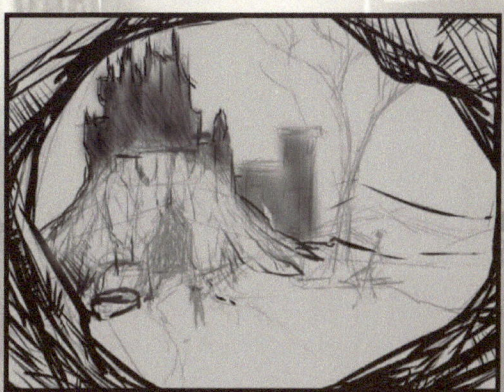

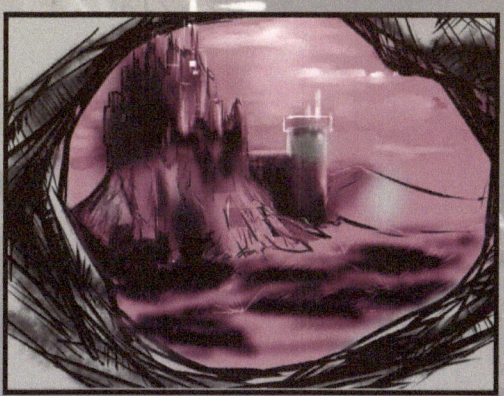

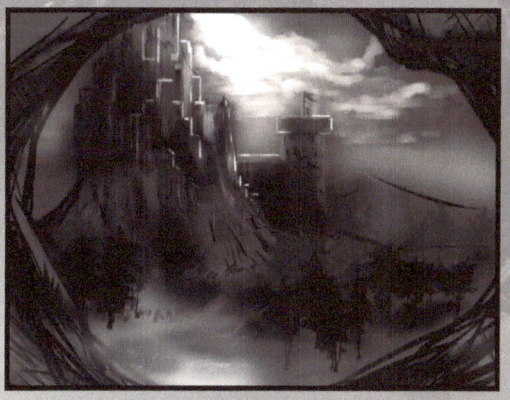

Spirit Falls

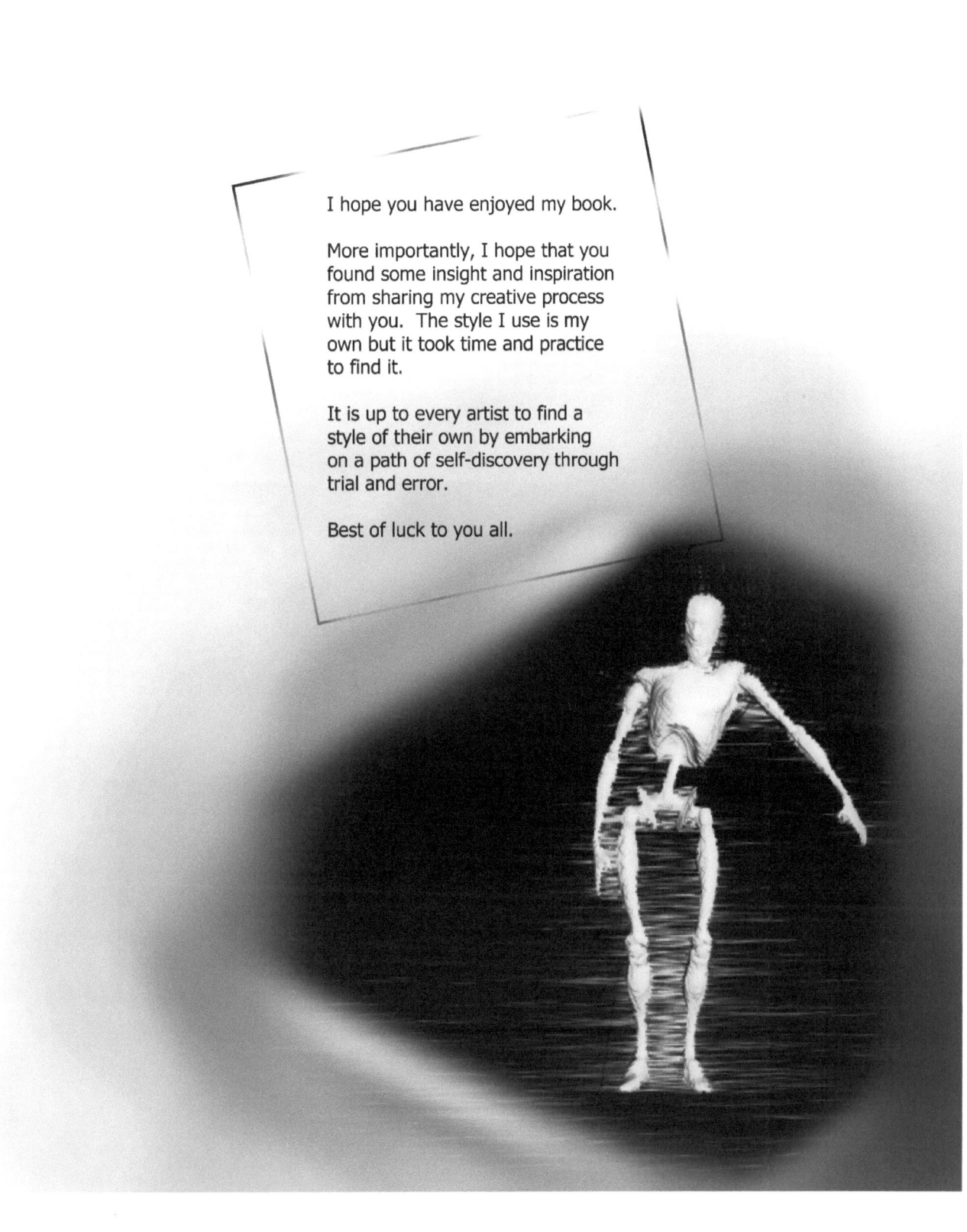

I hope you have enjoyed my book.

More importantly, I hope that you found some insight and inspiration from sharing my creative process with you. The style I use is my own but it took time and practice to find it.

It is up to every artist to find a style of their own by embarking on a path of self-discovery through trial and error.

Best of luck to you all.

ABOUT THE AUTHOR

Jeffrey Hunt is a freelance graphic artist specializing in digital designs. He has been creating illustrations for almost 20 years.

While Jeffrey is primarily a self-taught artist with some formal art training, he recently learned to use Clip Studio Paint as his primary design platform and has been using it for almost a year now. He recently wrote and created the webcomic Whilshire Manor while also continuing freelance work.

Jeffrey is veteran of the United States Armed Forces. He served in the United States Navy for nine years as an Enlisted Sailor. He is currently serving as a Logistics Officer in the United States Army.

While serving his country he has spent his leisure time dabbling with different art techniques available. His favorite medium is conventional ink and brush work and trees are one of his most popular subjects.

You can find most of Jeffrey's recent work in his online portfolio located on the web at http://www.jhuntgraphix.com.

www.ingramcontent.com/pod-product-compliance
Lightning Source LLC
Chambersburg PA
CBHW041311180526
45172CB00003B/1053